GRUMPY CAT'S®
not-to-dot book

Grumpy Cat's
not-to-dot book

DEMANDING DOT-TO-DOT ACTIVITIES FOR YOUR DISMAL EXISTENCE

Racehorse Publishing

Grumpy Cat®

Grumpy Cat and Related Artwork © and ® Grumpy Cat Limited
@RealGrumpyCat TheOfficialGrumpyCat
www.GrumpyCats.com · Used Under License

Racehorse Publishing books may be purchased in bulk at special discounts for sales promotion, corporate gifts, fund-raising, or educational purposes. Special editions can also be created to specifications. For details, contact the Special Sales Department, Skyhorse Publishing, 307 West 36th Street, 11th Floor, New York, NY 10018 or info@skyhorsepublishing.com.

Racehorse Publishing™ is a pending trademark of Skyhorse Publishing, Inc.®, a Delaware corporation.

Visit our website at www.skyhorsepublishing.com.

10 9 8 7 6 5 4 3 2

Cover and interior artwork by Diego Jourdan Pereira

ISBN: 978-1-63158-208-0

Printed in China

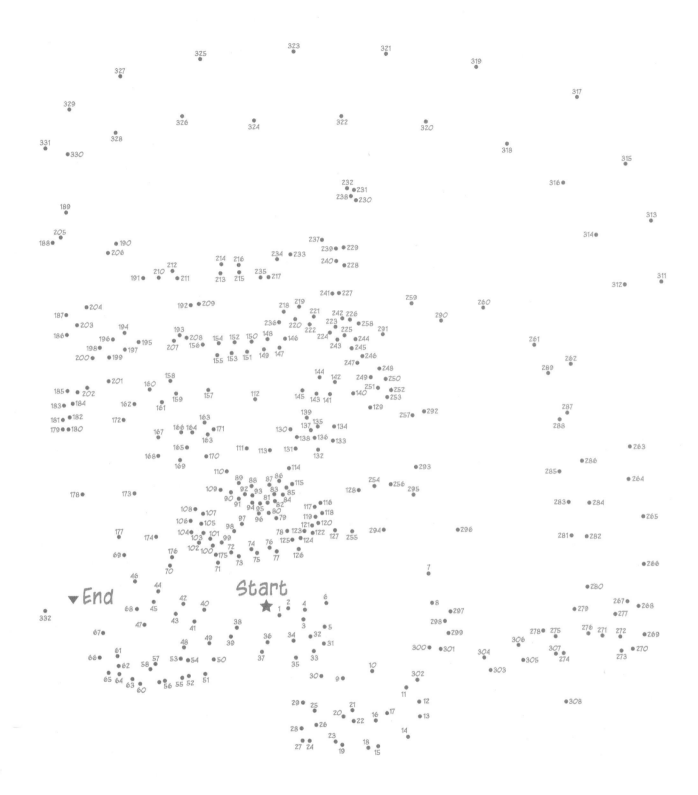

▼ End

Start

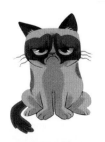

WELCOME TO MY NIGHTMARE.

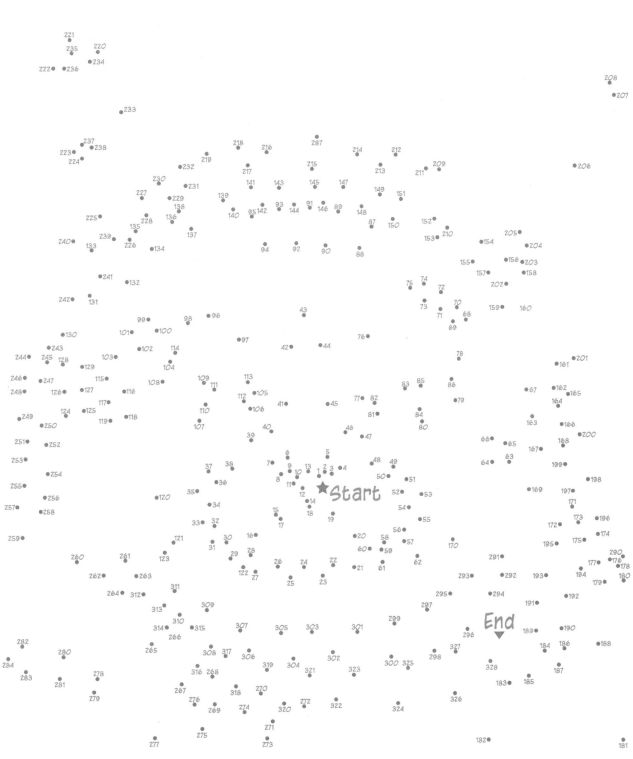

THIS SEEMS LIKE AN AWFUL IDEA.

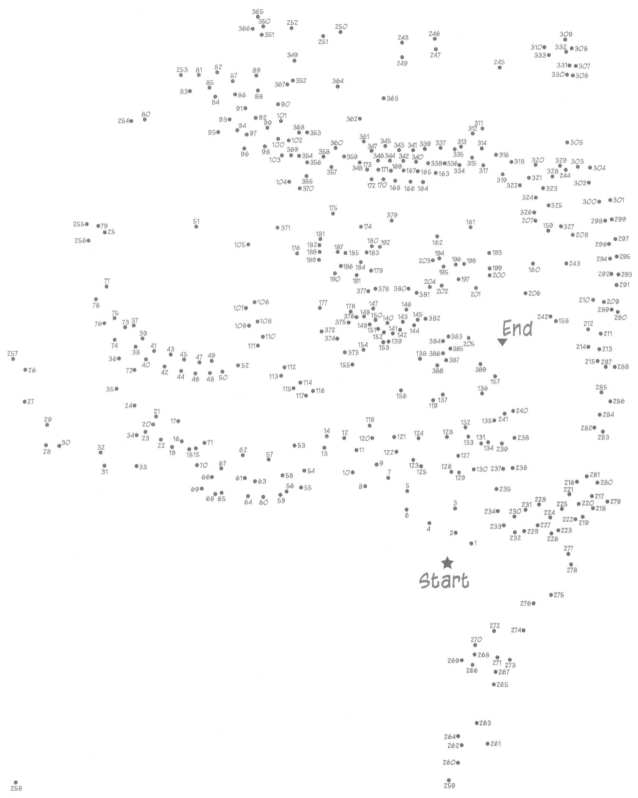

I THINK THIS IS SUPPOSED TO BE RELAXING...

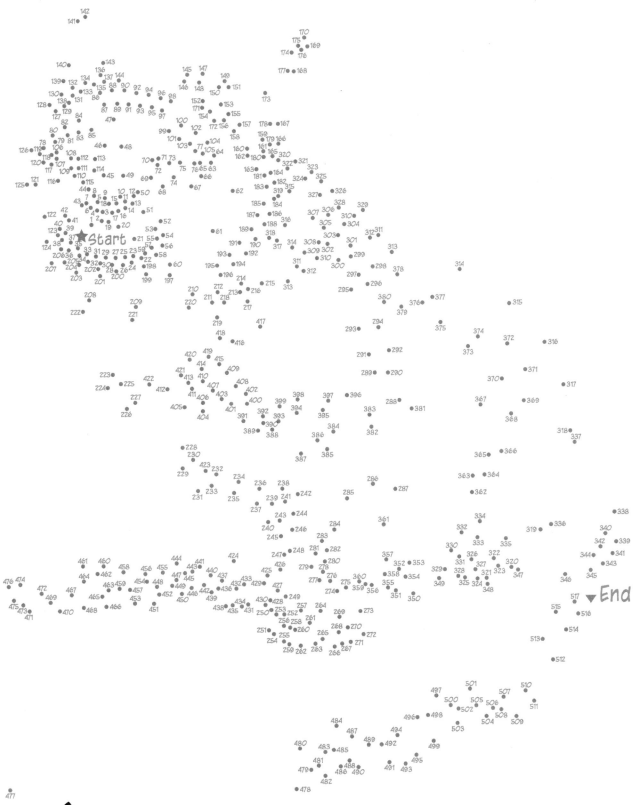

IS IT ME OR DOES ANYONE
HAVE TROUBLE SEEING THE PICTURES?

4

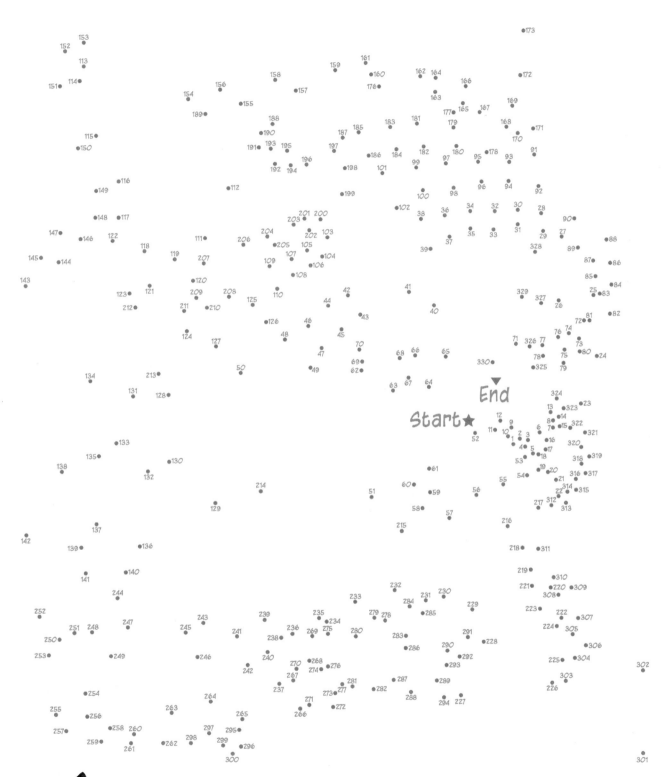

I'D GIVE YOU A CLUE, BUT I THINK YOU NEED A LOT MORE THAN ONE.

← 5

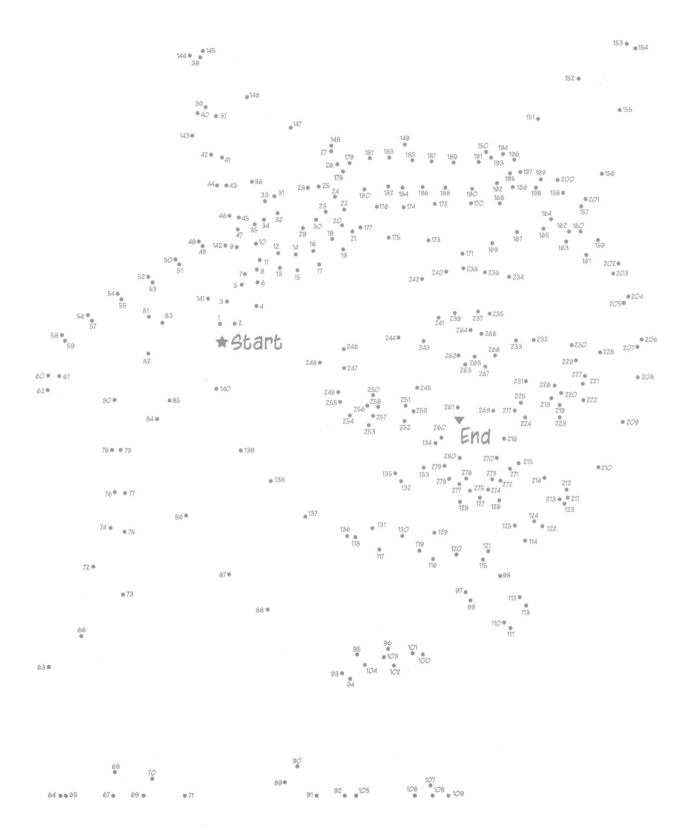

IS ANYONE ELSE ALLERGIC TO DOTS?

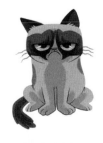

Start

End

I MAY BE ALLERGIC TO THIS BOOK.

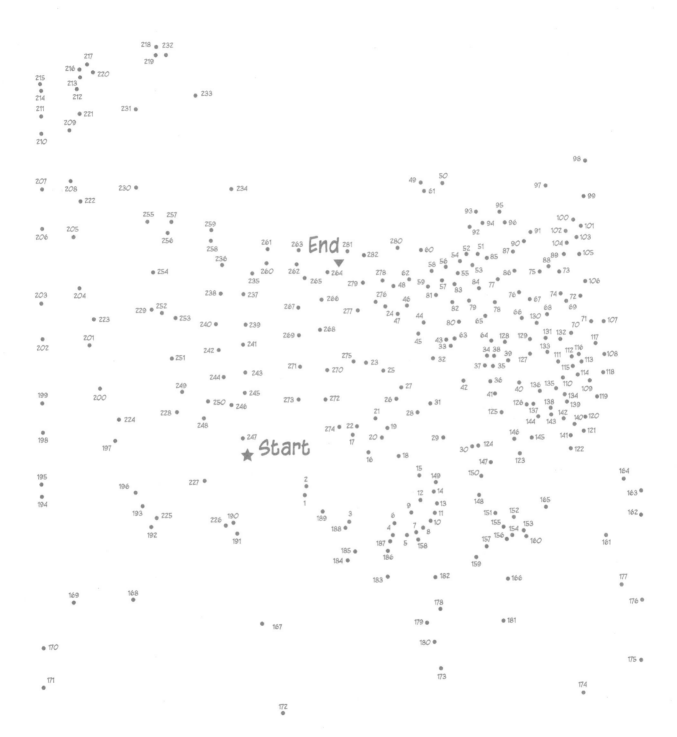

I'LL GIVE YOU A CLUE WITH THIS ONE, IT'S TERRIBLE.

8

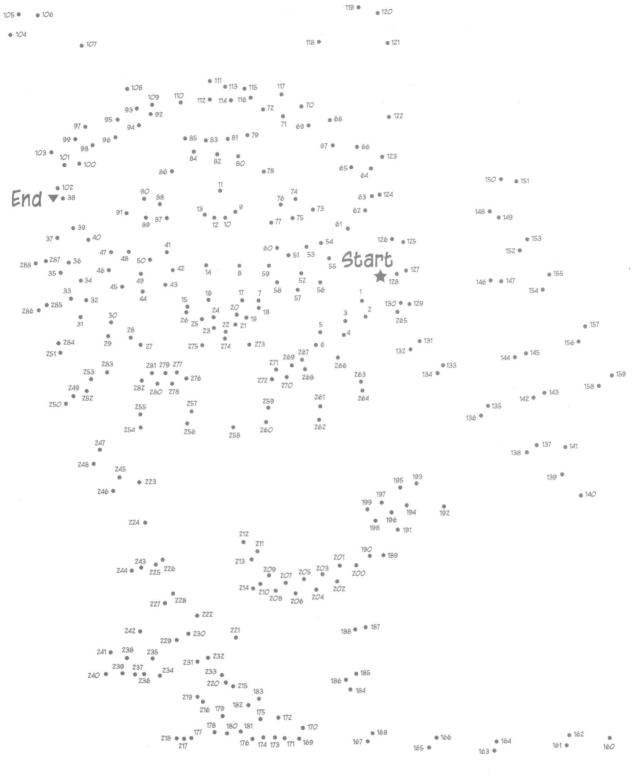

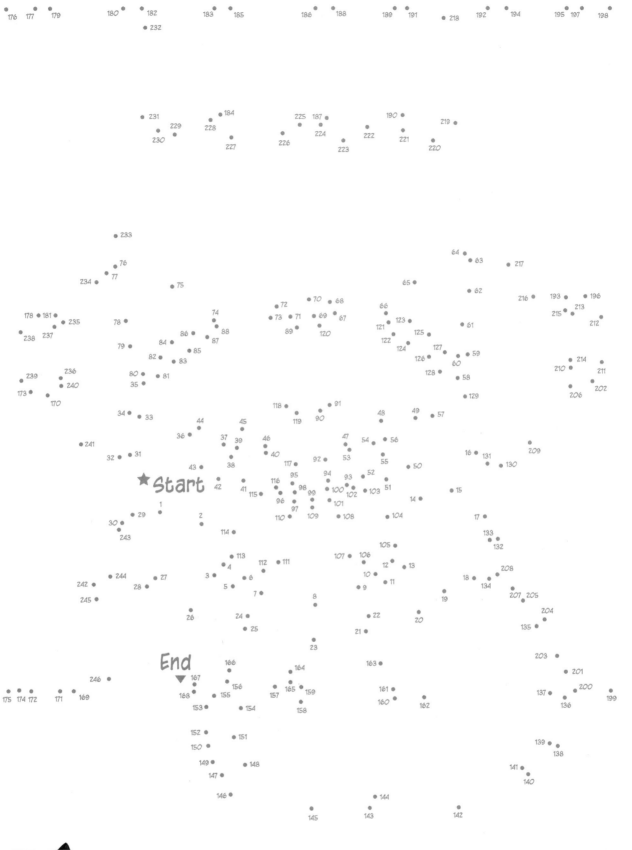

★ Start

End

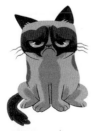

WHEN YOU FINISH THIS DOT-TO-DOT YOU'LL HAVE FOUND TRUE GREATNESS.

Start

End

THIS ONE WILL MAKE YOU SEE STARS.

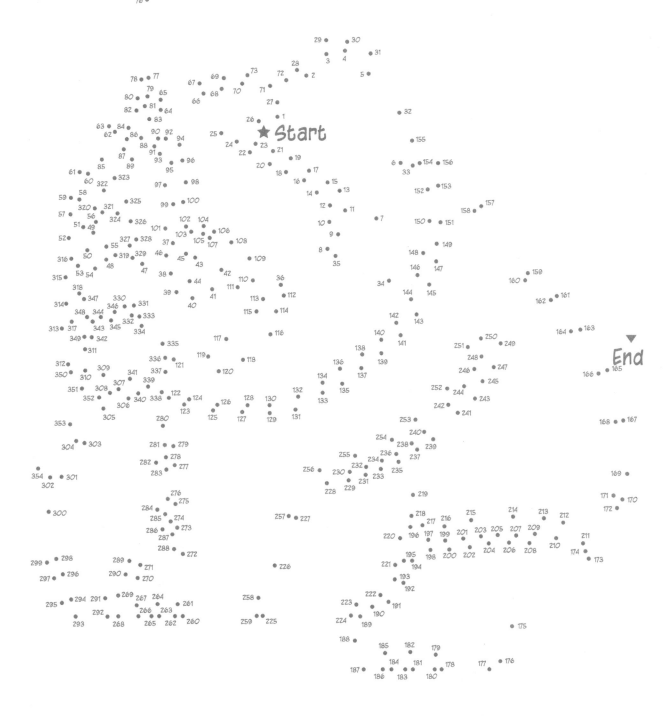

★ Start

End

I FEEL LIKE I'M LOOKING AT
A CONSTELLATION. IT'S AWFUL.

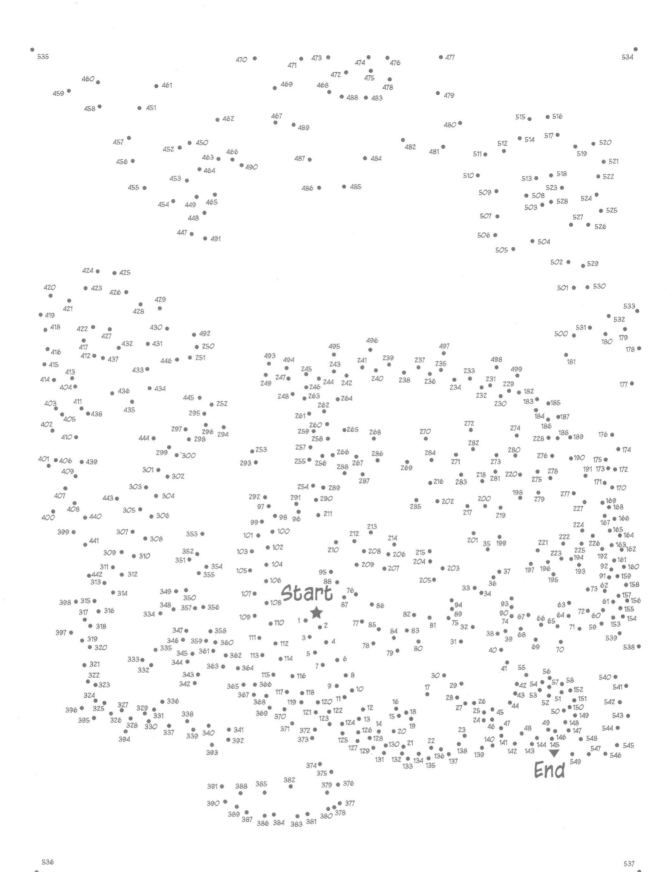

HOLD ON, LET ME TELL YOU YOUR HOROSCOPE. IN YOUR CASE IT'S MORE OF A HORRORSCOPE.

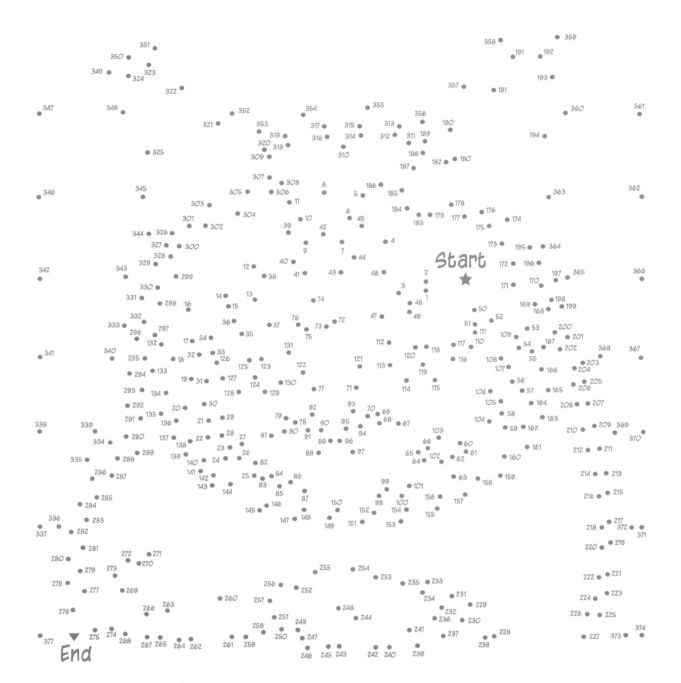

Start

End

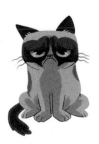

IF YOU GET TO THE END OF THIS ONE,
CONGRATULATIONS. I LOST COUNT
AROUND 300.

SERIOUSLY, HOW HAVE YOU GOTTEN THIS FAR?

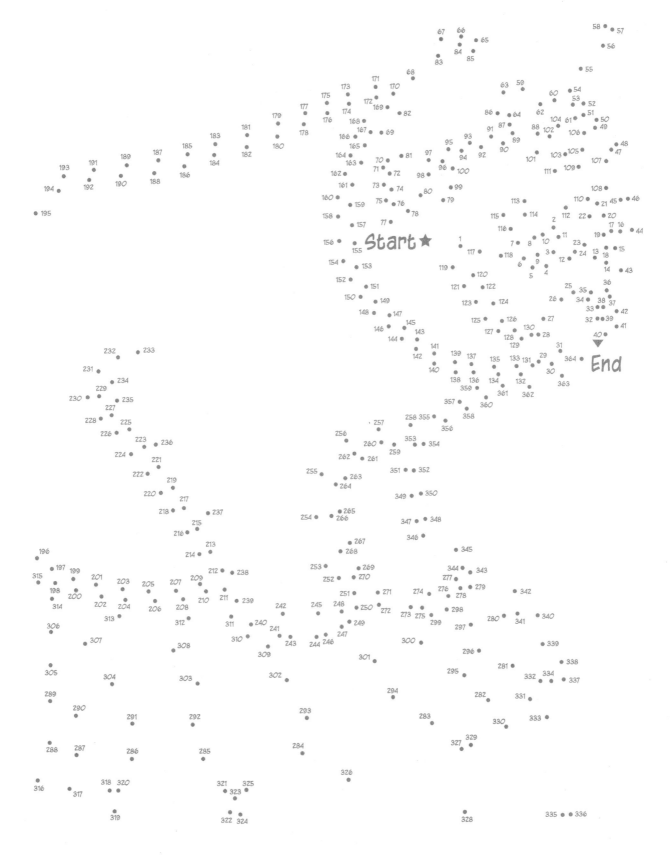

Start ★

End ▼

**HAVE YOU GOTTEN LOST YET?
WELL, YOU SHOULD GET LOST.**

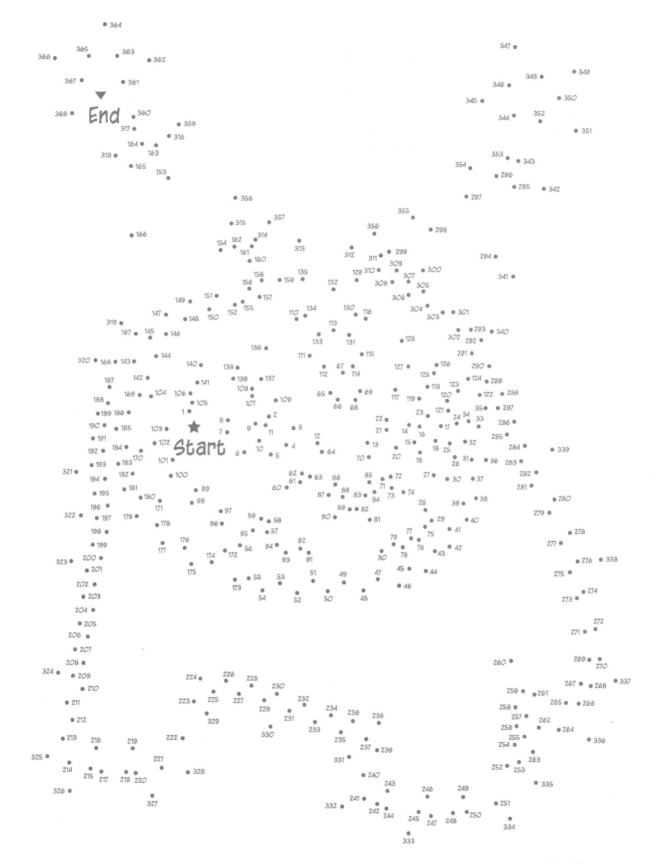

DOES THIS LOOK LIKE A DOG? THERE BETTER NOT BE A DOG IN THIS BOOK.

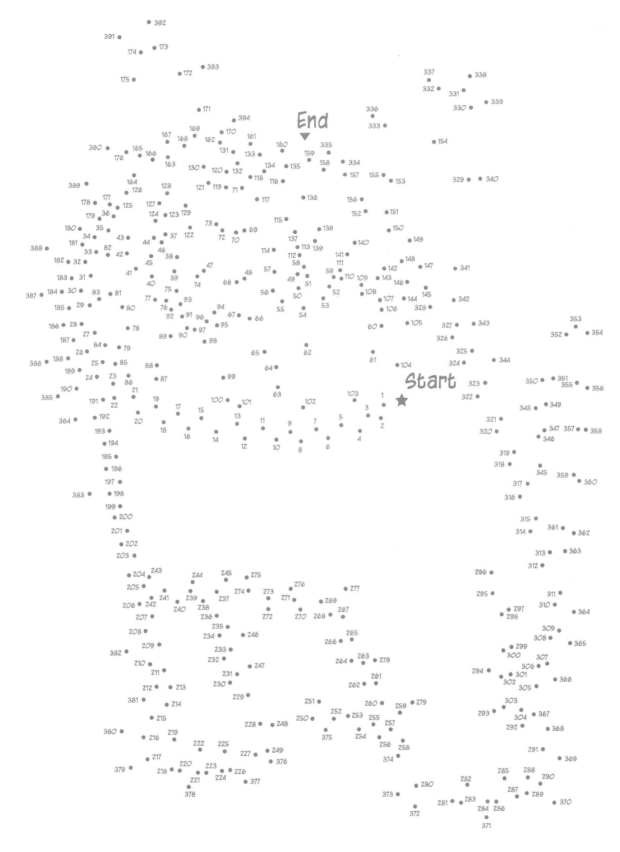

I APPLAUD YOUR DEDICATION, BUT THESE PUZZLES ARE IMPOSSIBLE.

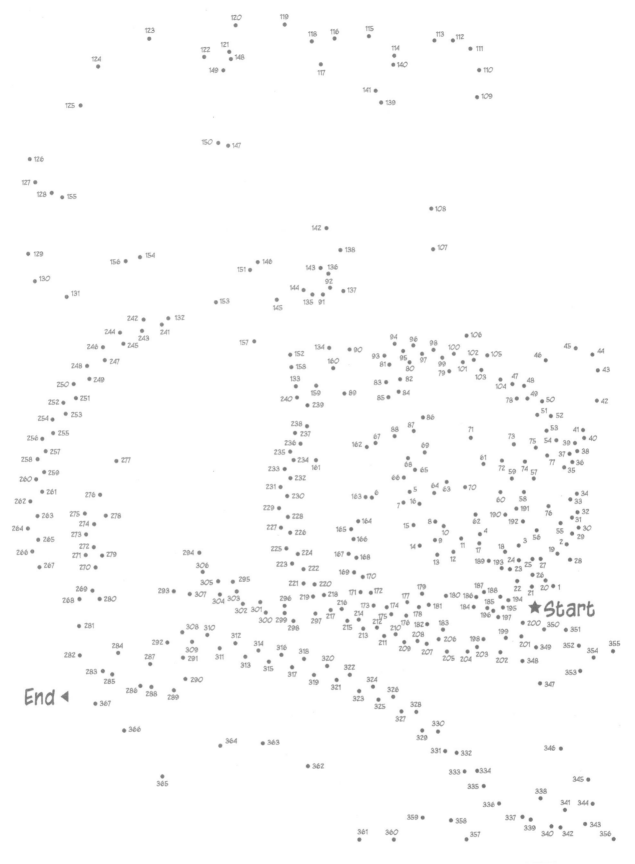

★ Start

End ◄

WAIT, I THINK I'M BEGINNING
TO UNDERSTAND THESE. NO, STILL
TOO DIFFICULT.

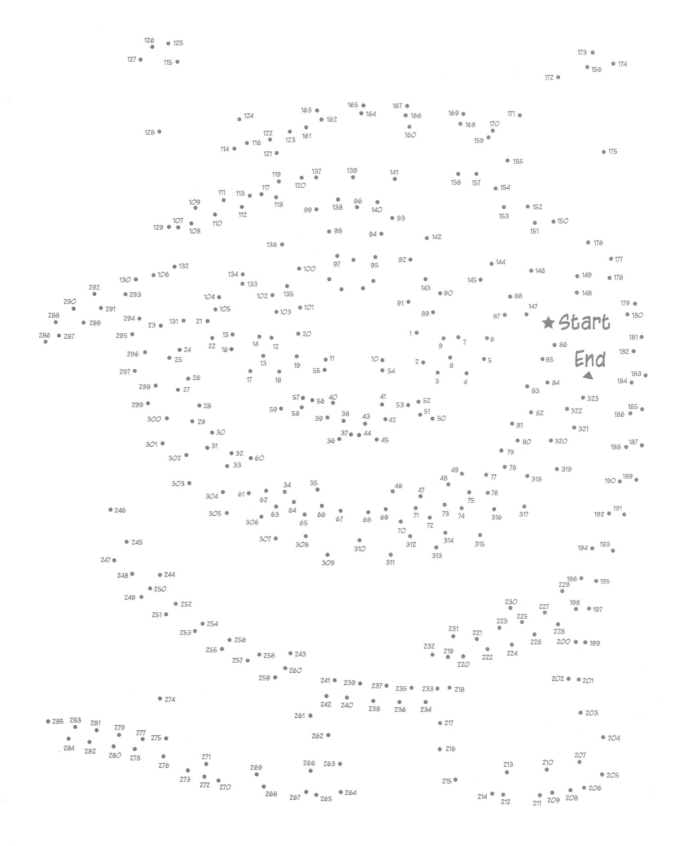

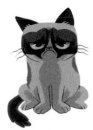

ARE YOU SURE YOU WANT TO KEEP GOING?

IS THIS A BAT? THERE BETTER NOT BE A BAT IN MY BOOK. I HATE BATS.

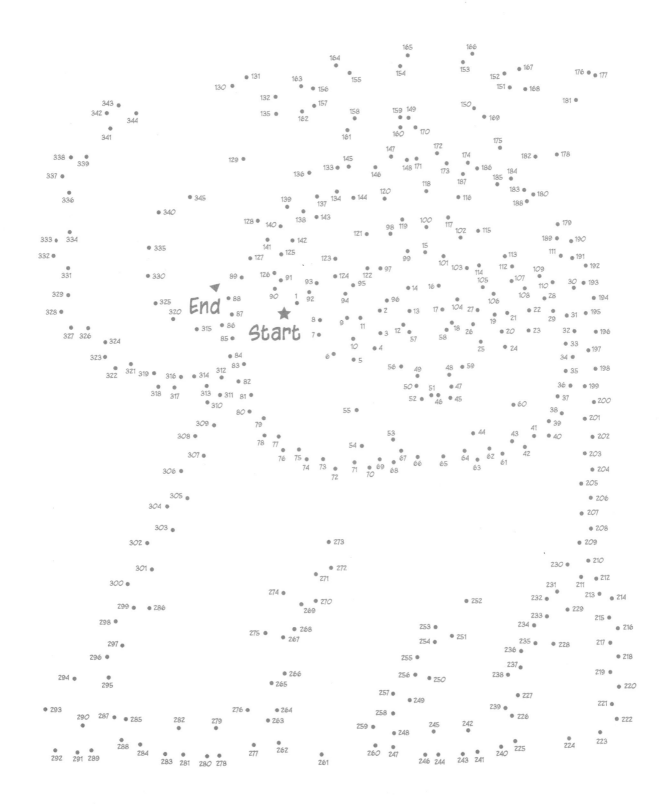

YOU MAY REJOICE IF YOU FINISH THIS ONE.

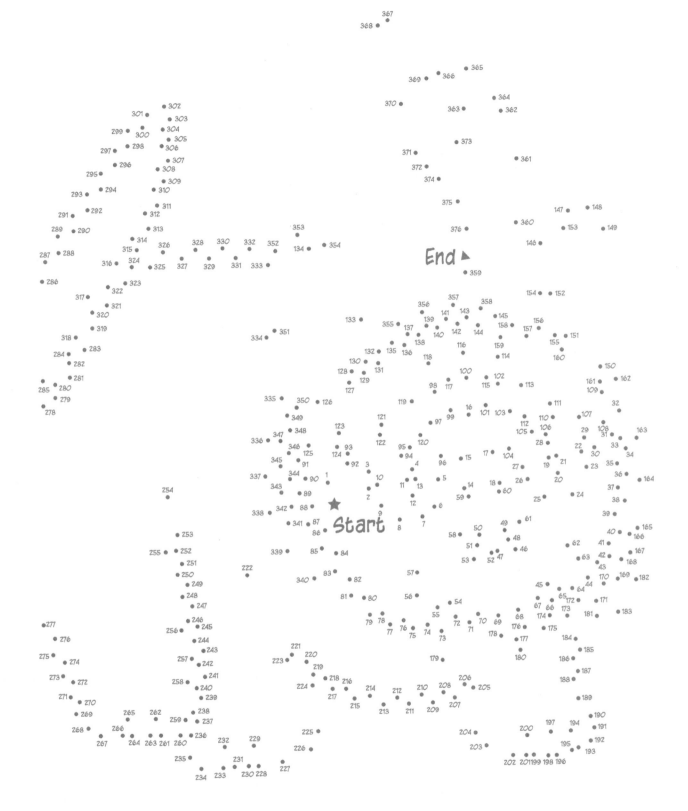

WORST DOT-TO-DOT EVER.

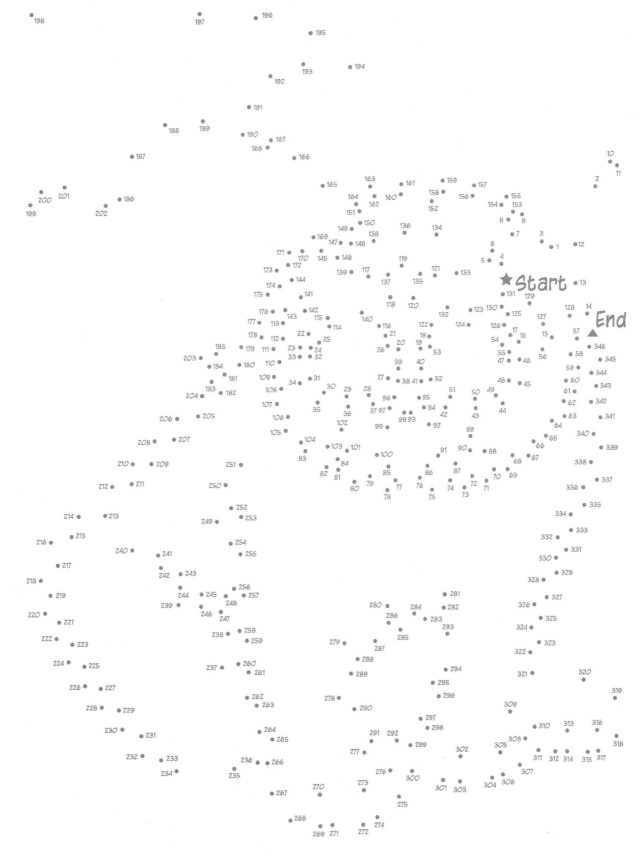

I GIVE THIS DOT-TO-DOT PERMISSION TO EXIST.

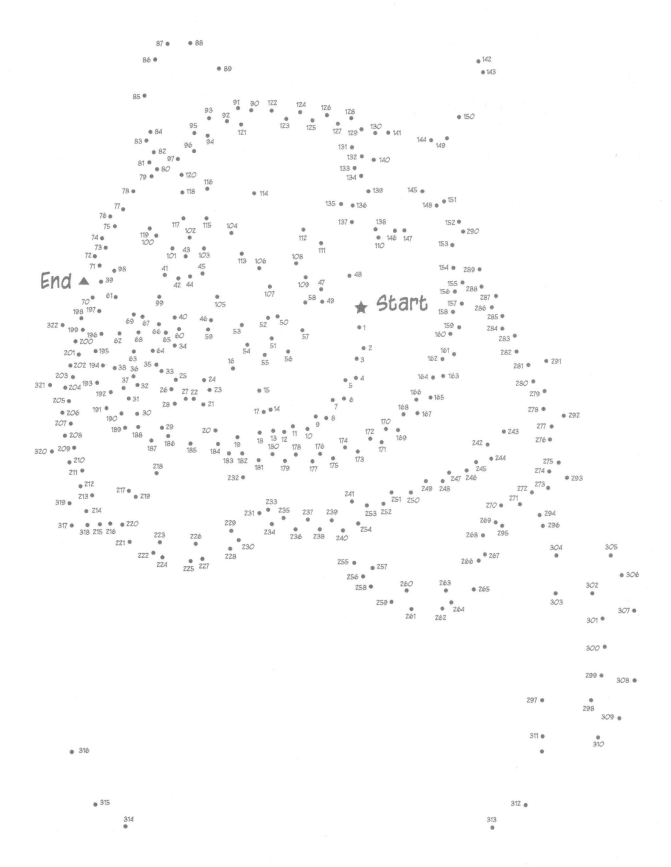

End ▲

★ Start

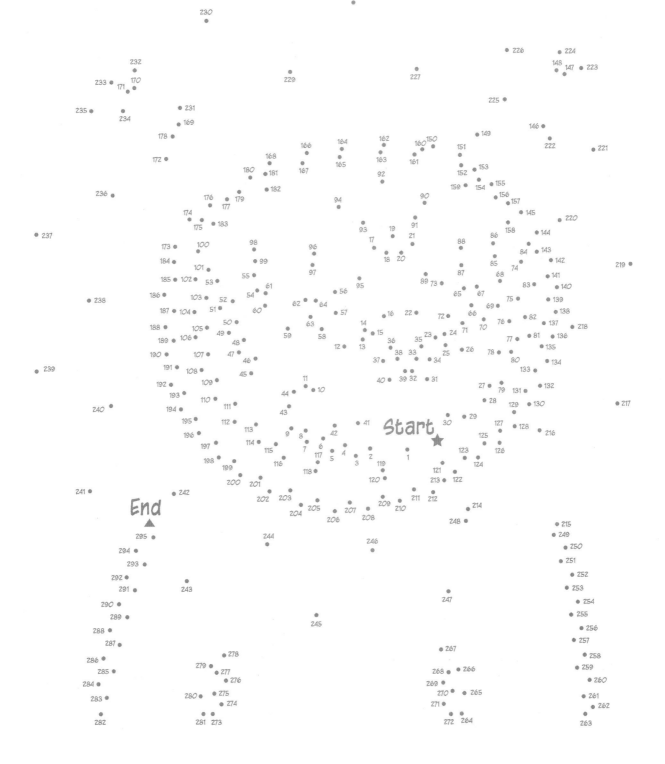

YOU KNOW WHAT IS WORSE THAN PUTTING YOUR CAT IN THINGS? DRESSING YOUR CAT UP.

NO MICE WERE HARMED CREATING THIS BOOK. WELL, MAYBE ONE.

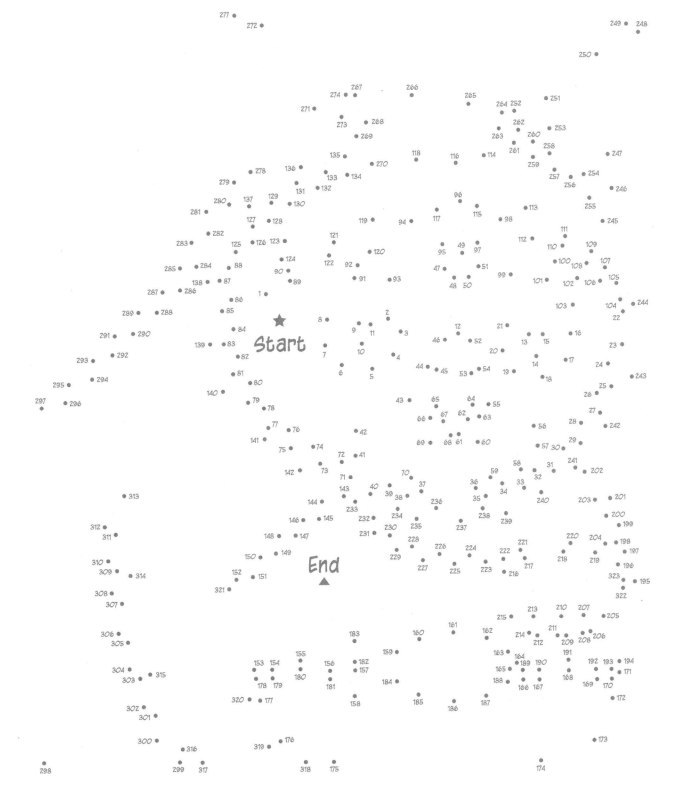

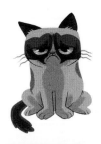

I HAD SUSHI ONCE. IT WAS AWFUL.

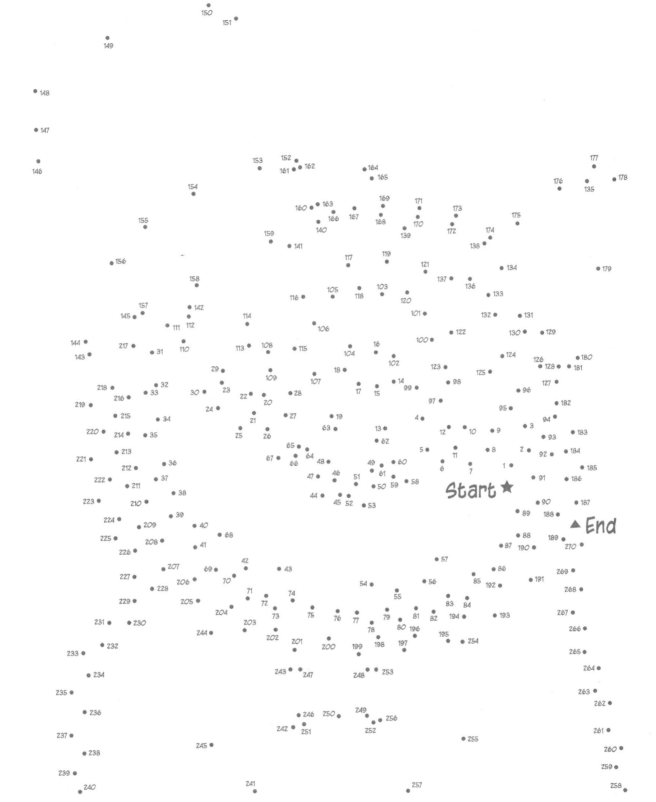

Start ★

▲ End

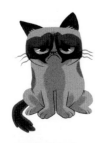

I'VE GOT A BAD FEELING ABOUT THIS ONE.

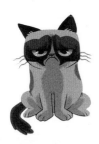

NO WAY.

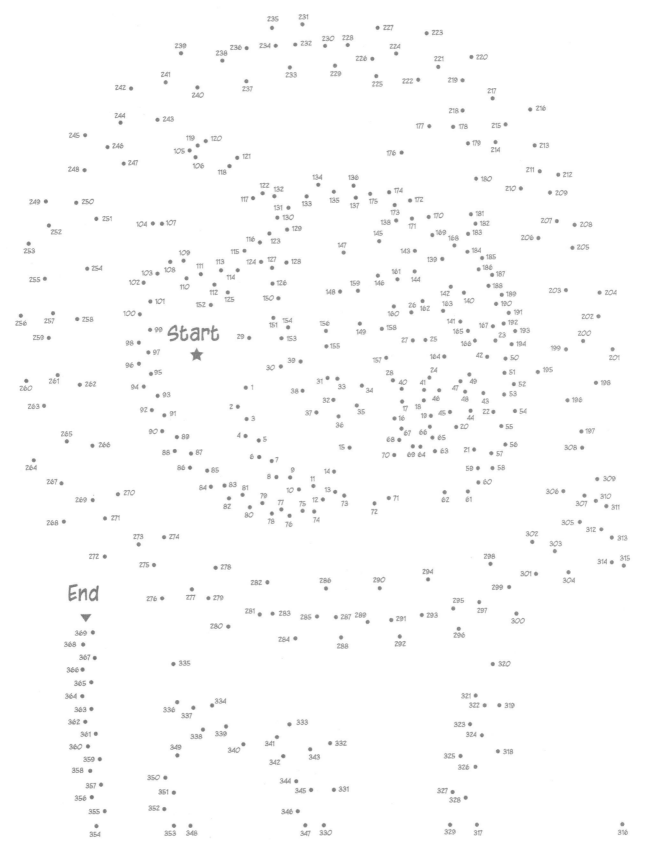

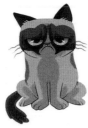

THIS HAS THE MAKINGS OF A TERRIBLE DAY.

THIS REALLY PUTS THE MEH IN MEMORIES.

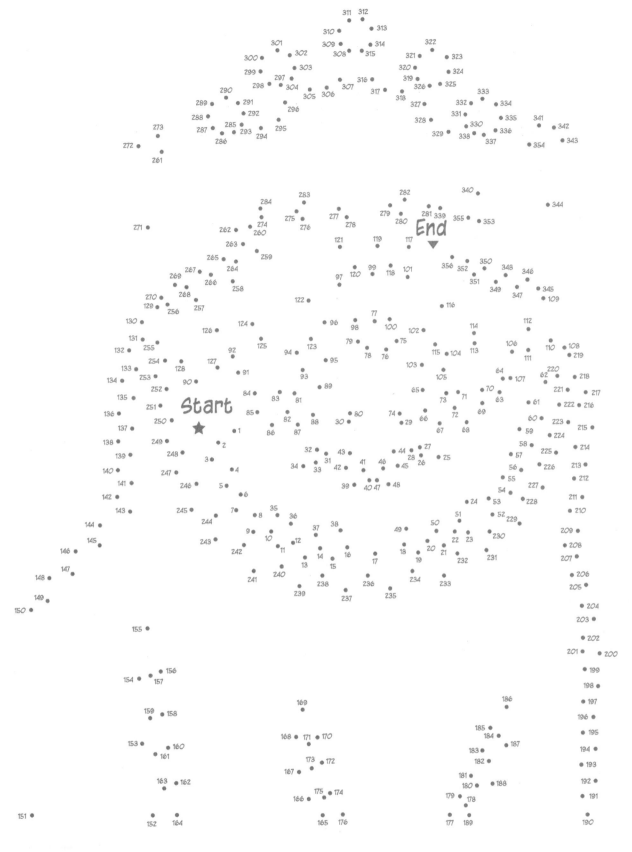

BEST DOT-TO-DOT EVER.

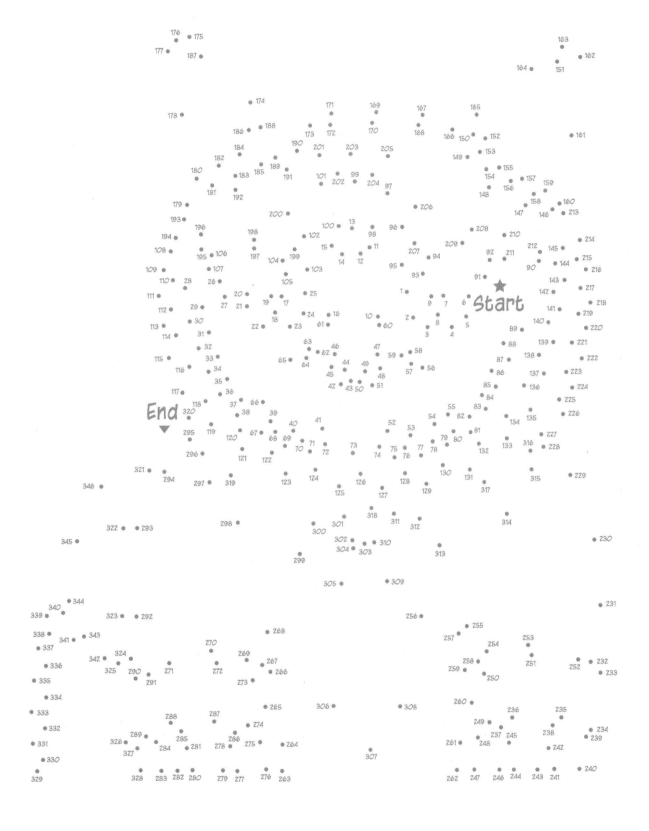

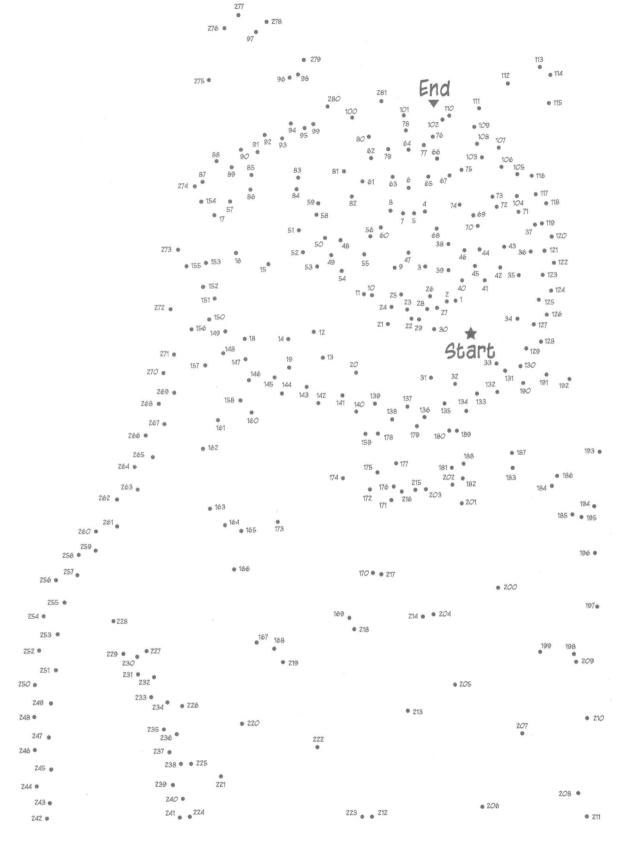

OH, IT ONLY GETS BETTER.

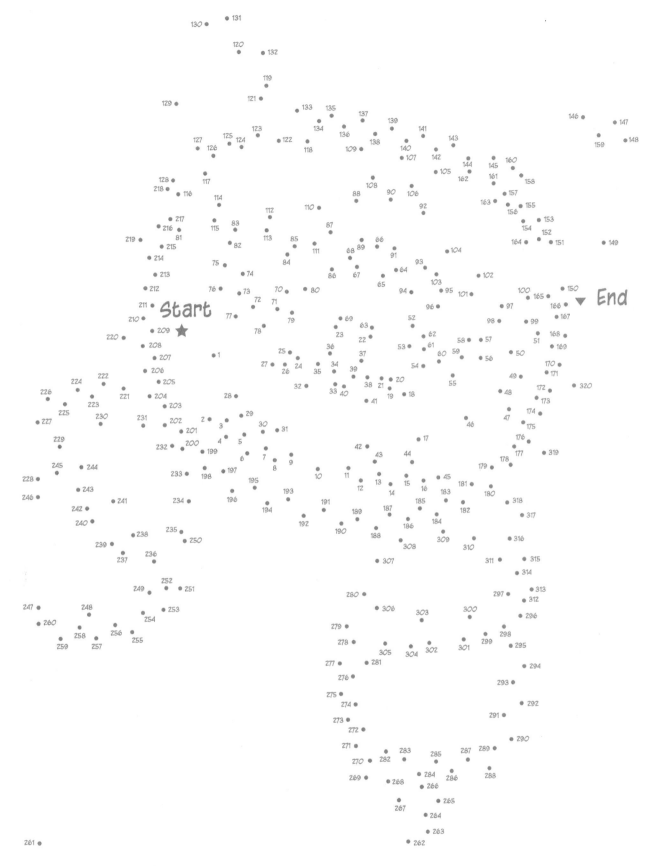

Start

▼ End

318, 319, WAIT... LET ME START AGAIN.

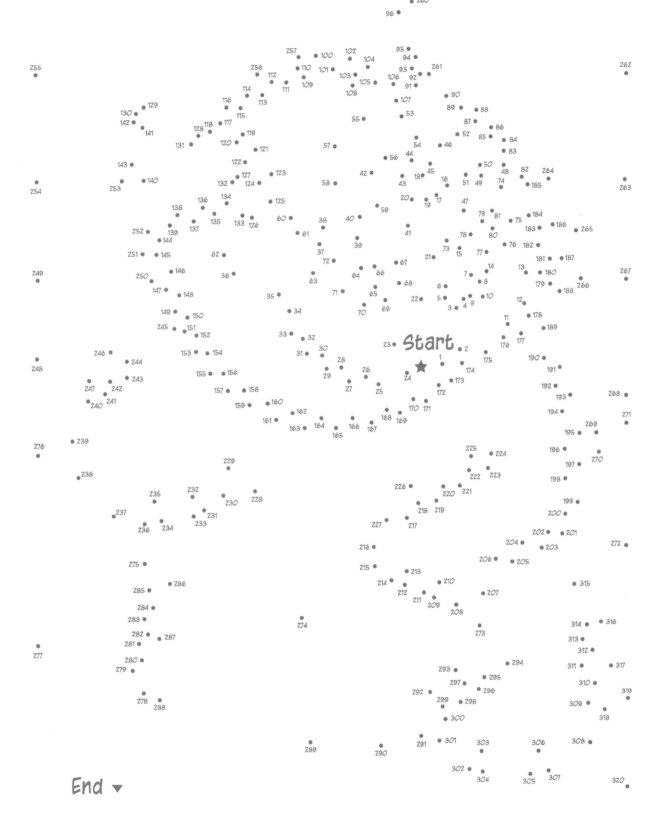

Start

End ▼

THIS BOOK IS A REASON TO BE GRUMPY.

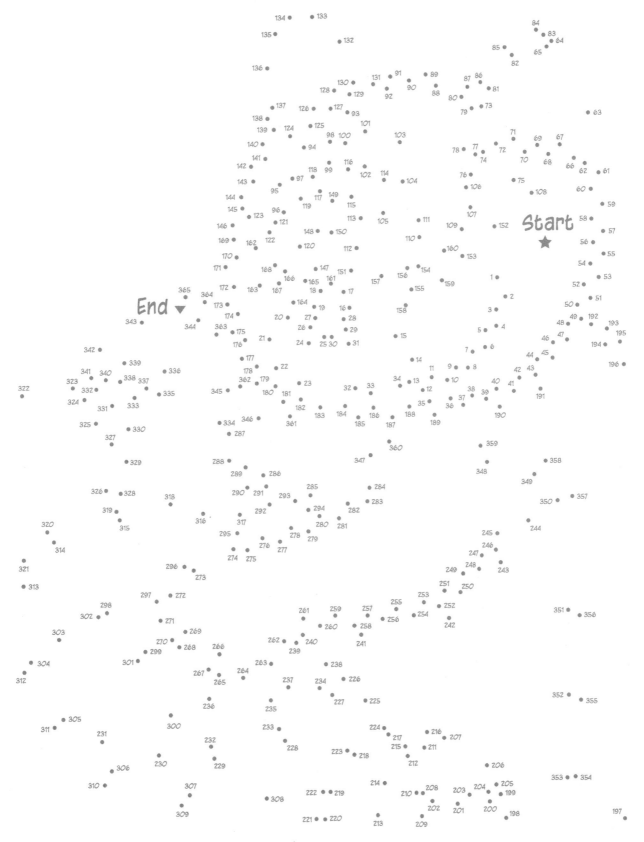

SOME PEOPLE NEVER LEARN.

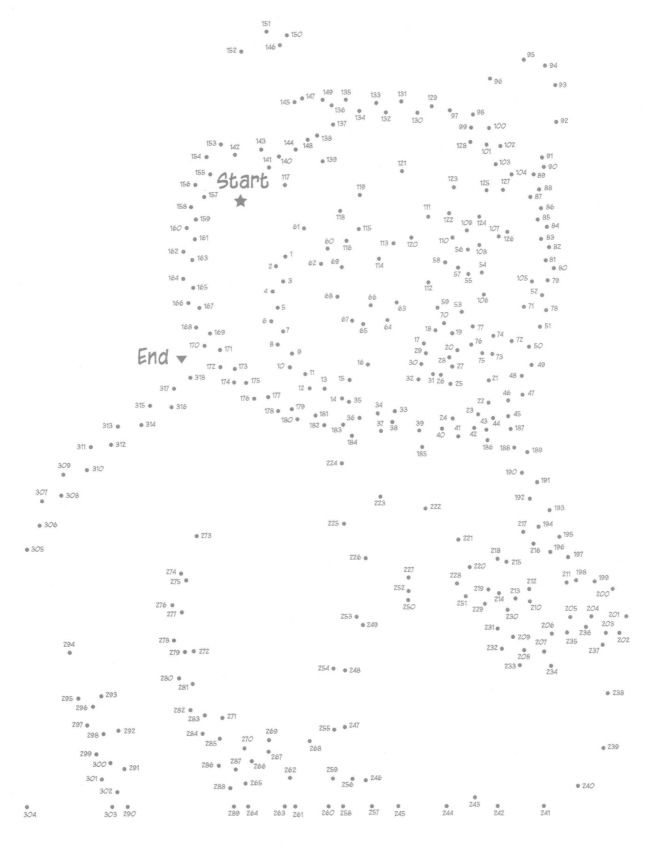

IF I HAVE OFFENDED YOU SOMEWHERE IN THIS BOOK... I DON'T CARE.

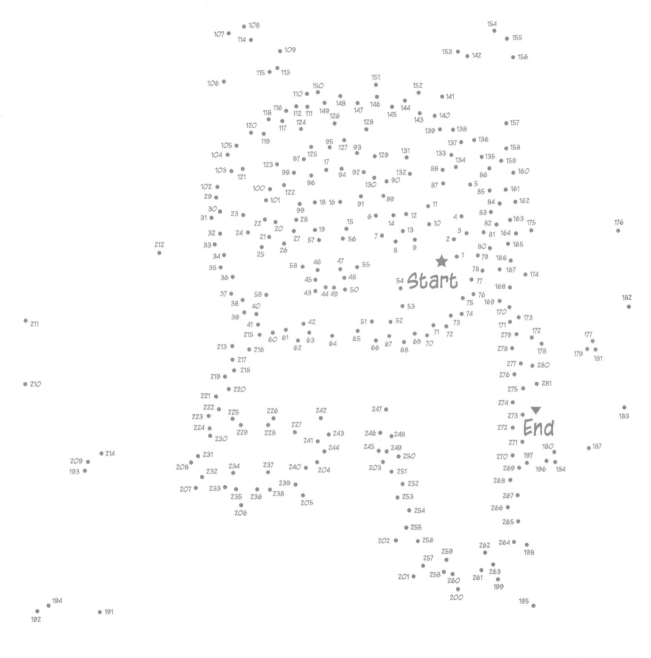

YOU MADE IT! LET'S NOT DO THIS AGAIN.

answer key

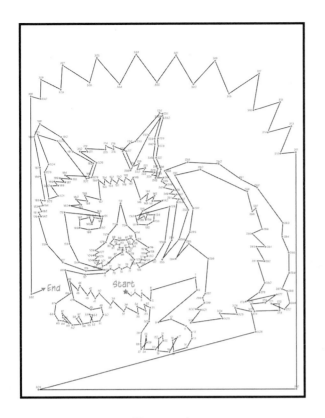

Page 1

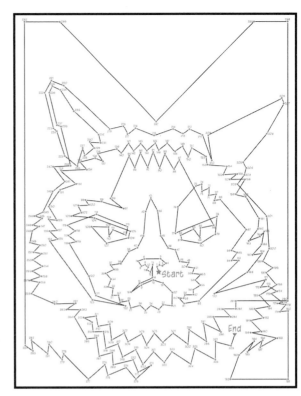

Page 2

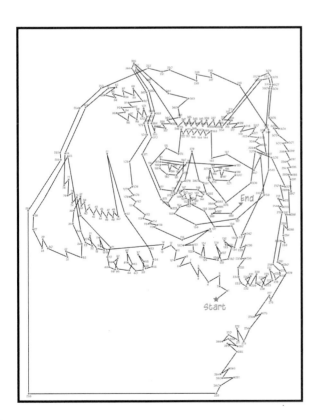

Page 3

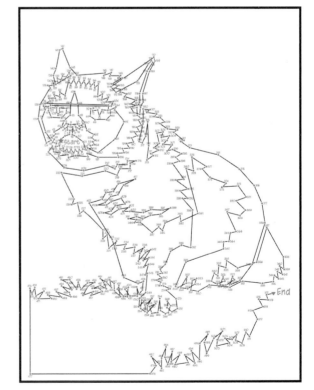

Page 4

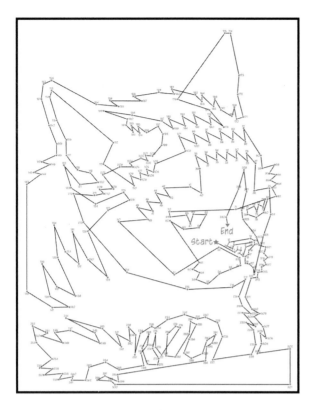

Page 5

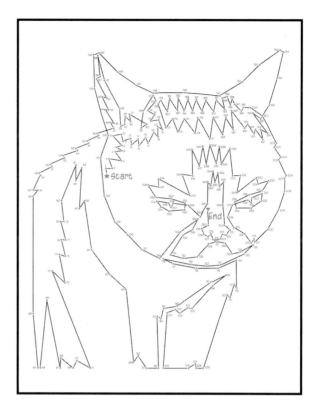

Page 6

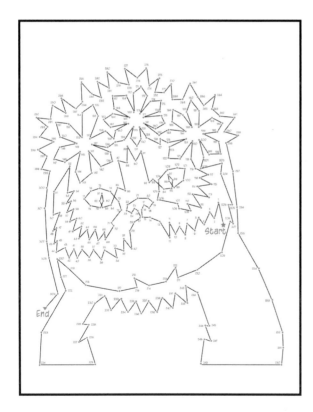

Page 7

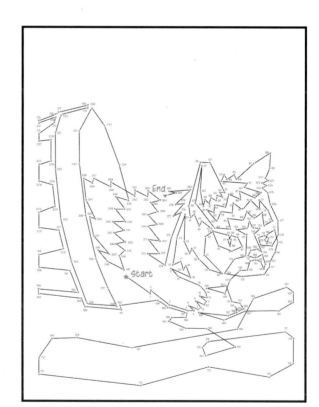

Page 8

Page 9

Page 10

Page 11

Page 12

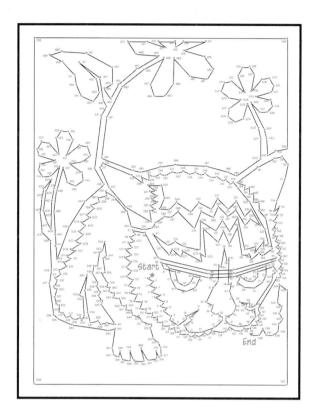

Page 13

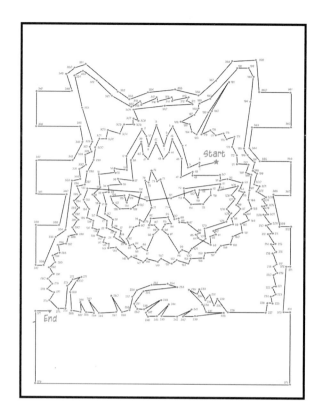

Page 14

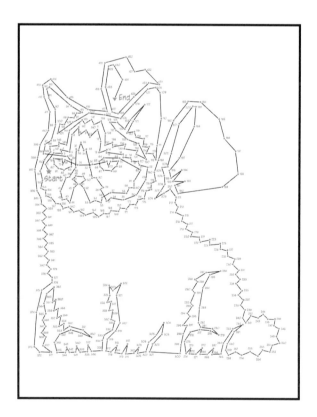

Page 15

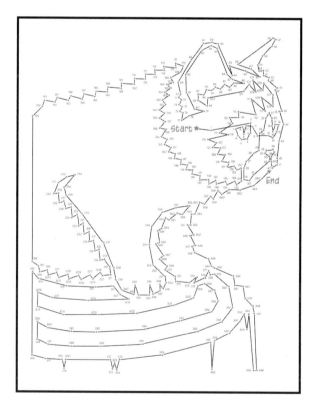

Page 16

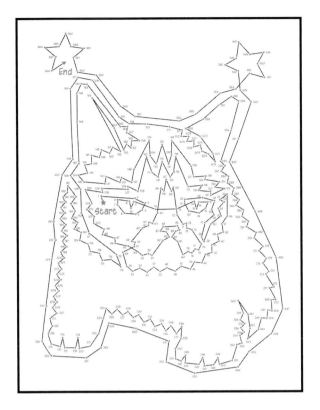

Page 17

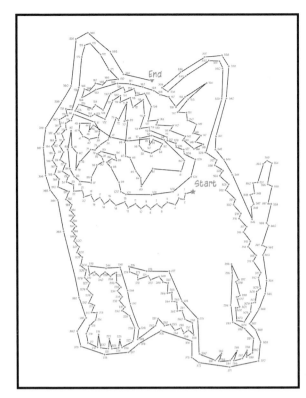

Page 18

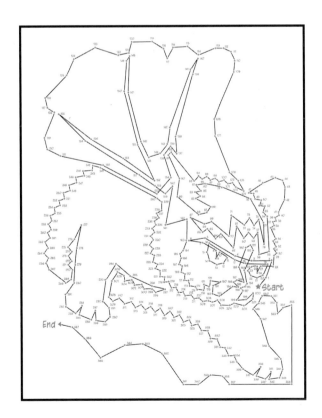

Page 19

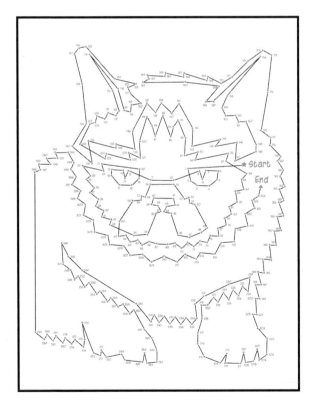

Page 20

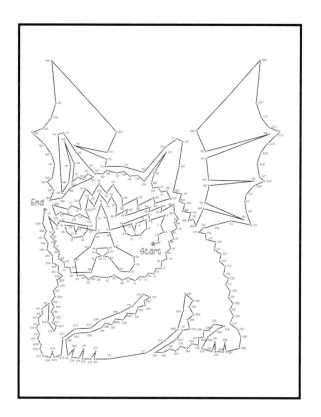

Page 21

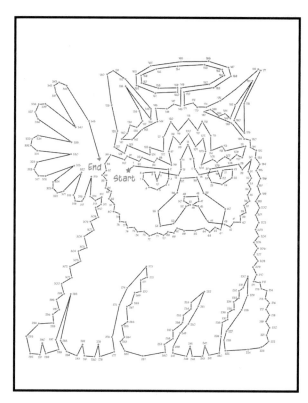

Page 22

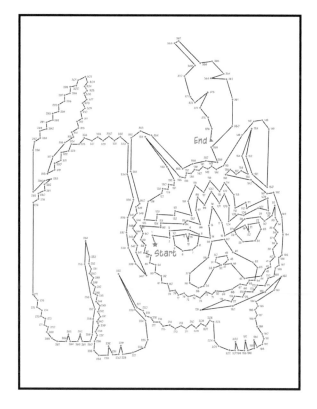

Page 23

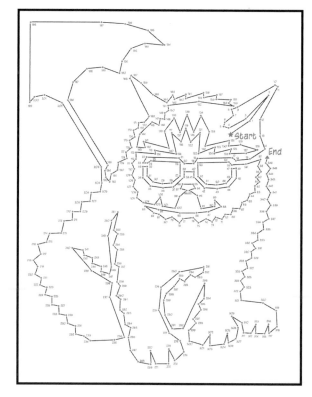

Page 24

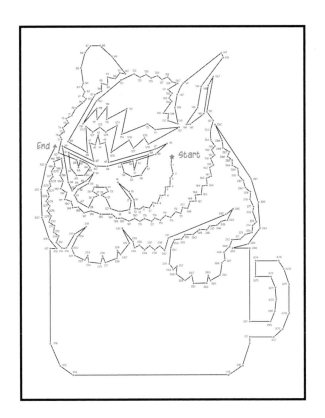

Page 25

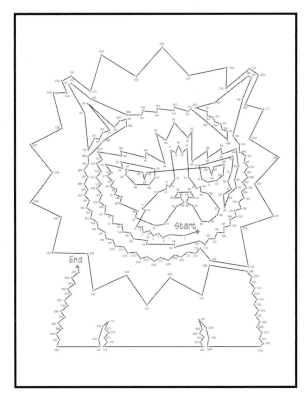

Page 26

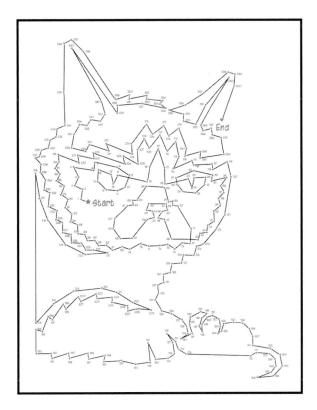

Page 27

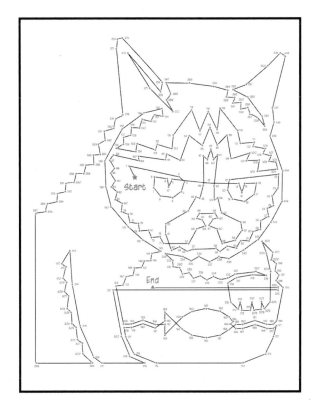

Page 28

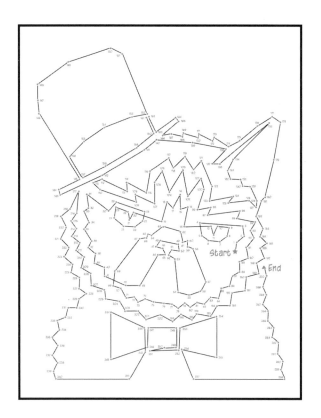

Page 29

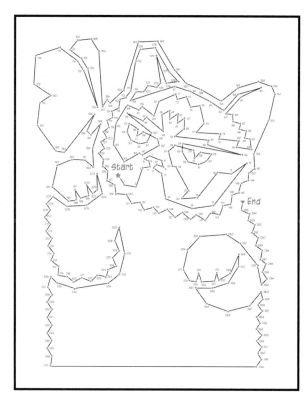

Page 30

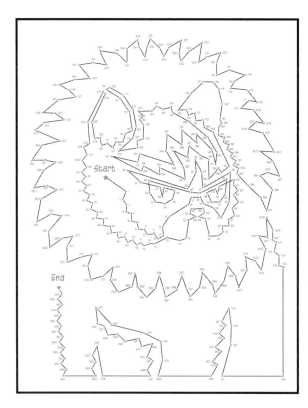

Page 31

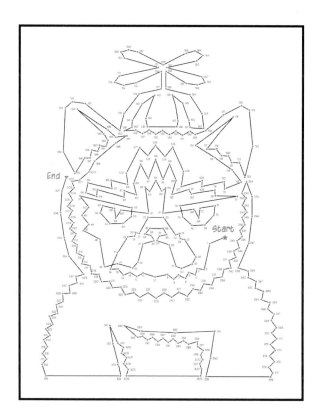

Page 32

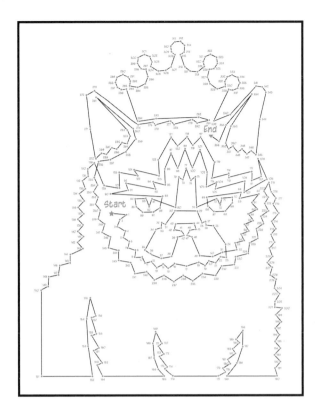

Page 33

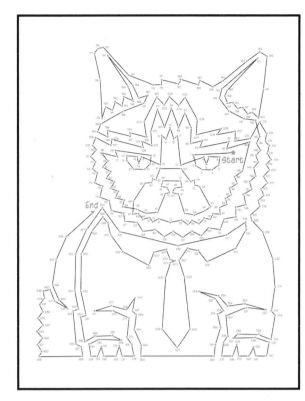

Page 34

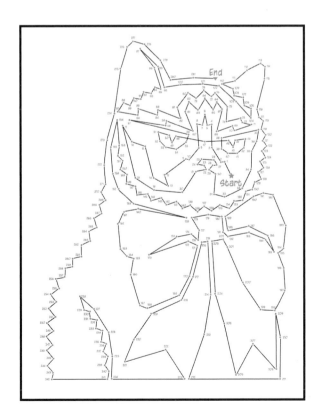

Page 35

Page 36

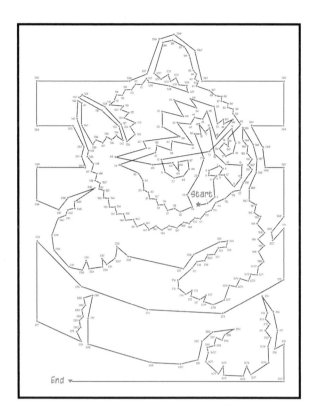

Page 37

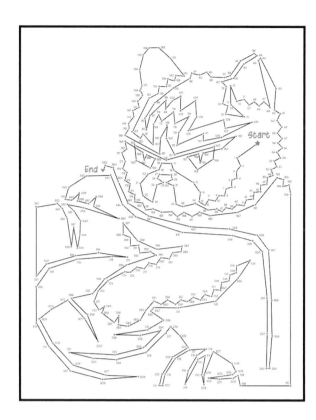

Page 38

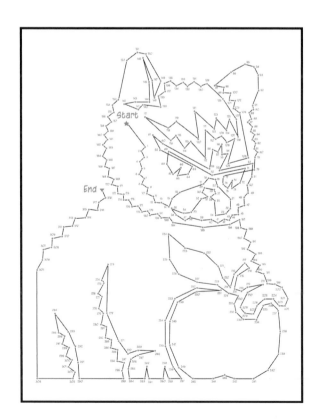

Page 39

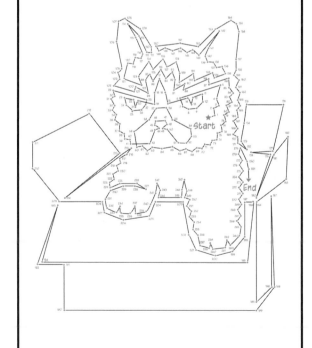

Page 40